IMAGES
of America

SINGER CASTLE

"Mystery hangs heavily over this Thousand Islands Castle. This element was helped in no little degree by the situation of Dark Island itself. Its name was appropriate. For as one approached it, either from up or down the St. Lawrence, it always seemed a darkling hulk against the background of the sunlit river. But now, it wears a different face. For piled up on the centre of the rocky ridge forming the background of the island stands the castle."—the *New York Times*, September 10, 1905.

IMAGES
of America

SINGER CASTLE

Robert and Patty Mondore

ARCADIA

Published by Arcadia Publishing,
Charleston SC, Chicago IL, Portsmouth NH, San Francisco CA

Printed in the United States of America

Library of Congress Catalog Card Number: 2004115844

For all general information, contact Arcadia Publishing:
Telephone 843-853-2070
Fax 843-853-0044
E-mail sales@arcadiapublishing.com
For customer service and orders:
Toll-free 1-888-313-2665

Visit us on the Internet at www.arcadiapublishing.com

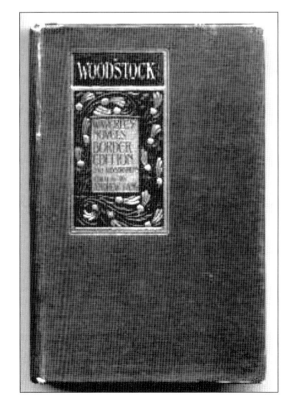

Singer Castle was designed by Ernest Flagg, who had just finished reading Sir Walter Scott's *Woodstock,* a historical novel about a mysterious castle located in Woodstock Park (Oxford, England). Hence, the castle on Dark Island was patterned after the one that had stood in Woodstock Park, complete with dungeons, turrets, labyrinths, and even secret passageways.

CONTENTS

ACKNOWLEDGMENTS

This is not the first time we have had the honor of acknowledging people and organizations that have helped us in putting together a presentation on Singer Castle. Many of the following also contributed to the making of our documentary video, *Dark Island's Castle of Mysteries* (www.gold-mountain.com/projects.html). So, once again, we would like to thank them for their invaluable assistance, images shared, and permissions granted. This project would simply not have been possible without the various contributions of each of those listed here: Harvey and Flo Jones; Alan and Marilyn Hutchinson and Verda Corbin, Corbin's River Heritage; Ralph Berry; Jean Marie Martello and David Martin, St. Lawrence County Historical Association; John Hunter, chief curator, Jekyll Island Museum; Roger Lucas; Farhad Vladi, Singer Castle; Ian Coristine; Michael Ringer; John Morrow; Jean Devaughan; Jeanne Snow, the Thousand Island Sun, Alexandria Bay; the LaSalle Christian Brothers, Narragansett, Rhode Island; Laura Foster, Remington Museum, Ogdensburg; Buffalo Bill Historical Center, Cody, Wyoming; William C. Clements Library, University of Michigan; and Universal Studios.

We dedicate this book to the memory of Eloise Dorsey Martin,
who passed away on December 29, 2004. She was the widow of
Dr. Harold George Martin, the owner of the castle on Dark Island
from 1965 until his death in 1999.

INTRODUCTION

Singer Castle is located in the heart of the Thousand Islands region on the St. Lawrence Seaway, which runs from the Gulf of St. Lawrence on the Atlantic Ocean to Duluth, Minnesota, on Lake Superior, a total distance of more than 2,340 miles. The section of the seaway referred to as the Thousand Islands is a 35-mile stretch that follows the northern border of New York State from Cape Vincent at the mouth of Lake Ontario to the small town of Ogdensburg. Although it is commonly referred to as the Thousand Islands, within that short distance there are actually over 1,800 islands, and on one of those lovely islands sits Singer Castle.

Dark Island is located near the village of Chippewa Bay. Singer Castle, originally called the Towers, was designed at the beginning of the 20th century by famous architect Ernest Flagg for the island's new owner, Frederick G. Bourne, president of the Singer Sewing Machine Company. This five-story granite masterpiece comes complete with stone spiral stairways, Spanish red-tile roofs, copper gutters, and towers. In addition, it contains dungeons, turrets, subterranean labyrinths, and even secret passageways.

Frederick G. Bourne (1851–1919) was born in New England, the son of a minister of modest means. While he was still young, his family moved to New York City. It was there, while singing in his church choir, that he met the son of the president of the Singer Sewing Machine Company. Alfred Clark began to send the young man to company meetings as his proxy, and the business-minded Bourne eventually worked his way up to becoming the fourth president of the company. Under Bourne's talented leadership, the business grew and prospered, opening manufacturing facilities around the world. Bourne himself became one of the wealthiest men in America.

Bourne had numerous outside interests and was also an avid sportsman who enjoyed a wide range of sports, including boxing, hunting, fishing, and boating. He owned numerous boats and was a member of several yacht clubs in the area, including the New York Yacht Club, where he was named commodore in 1903. In the late 1800s, he decided to purchase his own private island in the Thousand Islands area and commissioned Ernest Flagg to design a "hunting lodge" for it. Coincidentally, at the time Flagg had just finished reading Sir Walter Scott's *Woodstock* (1832), one of the Scottish Waverley novels that described a mysterious castle with secret passageways used to protect the ousted King Charles from the independents led by Sir Oliver Cromwell. The castle on Dark Island was patterned after the one that had stood in Woodstock Park (near Oxford, England.)

Construction was begun in 1903 by the J. B. & R. L. Reid Company of Alexandria Bay. A total of 90 stonemasons worked on the project. In addition, Italian stone craftsmen were hired to shape the rose granite that would be quarried on Oak Island a few miles away. The work went on year-round for over two years. Finally, in 1905, the castle was completed at a total cost of nearly $500,000. Reminiscent of *Woodstock,* the castle was appropriately called the Towers by Bourne. It became the summer home and fall hunting lodge of the Bourne family until the original members' deaths. Frederick Bourne died on Sunday, March 9, 1919, just two and a half years after his wife passed away.

One of his daughters, Marjorie, took possession of Bourne's Towers and went to the island for a few weeks every summer. She later married Alexander D. Thayer. It was she who had several additions built onto the castle in the 1920s, including the breakfast room that was later used as a chapel. She eventually deeded the property to the LaSalle Military Academy of Long Island for $1. She died just a few years later (in 1962), leaving the island and its castle to the LaSalle Christian Brothers.

Unable to find suitable use for the castle, the academy put the property up for sale. As few were willing to take on the financial burden of maintaining a castle that could only be used a few months out of the year, in 1965 the Harold Martin Evangelistic Association, from Quebec, Canada, was able to purchase Dark Island for a mere $35,000. After taking possession, the president, Dr. Harold George Martin, had the name of the castle changed to Jorstadt (his family name had originally been Martin-Jorstadt).

Martin and his wife, Eloise, used their island castle as a private retreat for ministers and missionaries. They also opened the castle doors to the public throughout the summer months for Sunday morning chapel services commonly led by Martin himself. In 1985, when the Martins (for health reasons) were no longer able to spend their summers there, Jorstadt Castle appeared on the market again, this time at an initial asking price of $5 million.

Harold Martin asked Harvey and Flo Jones, a couple who had regularly attended them, to continue holding the Sunday chapel services for him in his absence. Martin passed away in November 1999, and the ministry was then owned and operated by his son Wycliffe Martin, who was named president of the Harold Martin Evangelistic Association. The Joneses continued to run the Sunday chapel services.

In July 2002, a group of investors called Dark Island Tours purchased the island and its castle for $1.8 million. The owners immediately began to restore the aging castle and related structures to their original condition with the intention of opening the castle doors to the public for tours. Today, throughout the summer months, tourists are welcome to visit the castle and its grounds and to see for themselves why the *New York Times* called it the "Castle of Mysteries."

Authors' note: We have included a number of quotations from Sir Walter Scott's *Woodstock* in our pictorial tour of the castle, perhaps even some of the very words that inspired Ernest Flagg as he designed the castle on Dark Island for Frederick Bourne.

One

INSIDE THE CASTLE

The castle on Dark Island is a five-story masterpiece that is now over 100 years old. This book begins by taking readers on a tour of Singer Castle, starting with a walk through its five stories and 28 rooms. After reaching the top of a winding stone path leading up from the main dock, visitors arrive at the main entrance of the castle.

At the top of the stone pathway leading up from the main docks, there is a small patio with several stone benches just outside the main entrance of the castle. After enjoying the breathtaking view of the river, visitors first enter the castle by passing through its massive wooden front doors.

The main doors lead directly into the great hall. This magnificent entrance room, or vestibule, is 39 by 33 feet and features beautifully carved stone arched walls, massive pillars, and ceilings artistically formed by crews of Italian masons. It has been described as a cavernous vaulted space that, due to its spatial complexities, creates a number of perspective views that complicate the visitor's spatial perception.

MAIN ENTRANCE, THE TOWERS

This was one of the postcards made of the castle during the time period of Frederick Bourne's daughter Marjorie. "The way, therefore, lay open to the great hall or outer vestibule of the lodge. . . . One end was entirely occupied by a gallery, which had in ancient times served to accommodate the musicians and minstrels. There was a clumsy staircase . . . and in each angle of the ascent was placed, by way of sentinel, the figure of a Norman foot-soldier. . . . Their arms were buff-jackets or shirts of mail, round bucklers, with spikes in the center, and buskins which adorned and defended the feet and ankles. These wooden warders held great swords, or maces, in their hands, like military guards on duty."—*Woodstock*, by Sir Walter Scott.

The great hall also features a large stone fireplace located below a stone shelf covered with antiques. The mirror over the fireplace faces another mirror directly across the room on the opposite wall, the two reflecting an infinity of reciprocal views. The room is adorned with suites of armor standing guard over a collection of antique weaponry. The two doors opposite the main entrance lead to the wine cellar (above) and the kitchen area (below).

The wine cellar is accessed directly from the great room. It is a small closetlike room with a generous supply of wine racks. It is handily located at the base of the stairs leading from the great hall to the main floor and is also right next to the entrance to the kitchen area.

The suite of rooms that includes the kitchen (24 by 24 feet) also contains a breakfast room, a pantry for food storage, a dumbwaiter, and a spiral staircase that leads to the dining room on the main floor. From the kitchen, people can look out over the castle grounds to the north boathouse and across the water to the Canadian shore. There is also a door exiting the castle from the kitchen.

The kitchen area also includes a sitting-dining room (18 by 10 feet) finished in walnut. This room has a beautiful view overlooking the south boathouse and the main shipping channel. A spiral staircase leads from this room to the clock tower and down to the boathouse. This photograph shows some of the lovely antique furnishings. There is also a lovely wooden dining room table in the center of the room. Note the hall leading to the eastern wing.

Just behind the kitchen area is a hall leading into the eastern wing, which includes five staff bedrooms (one is pictured), labeled as "servants rooms" on the original blueprints. This section also includes a bathroom, a large utility room, and a door that leads to the beautifully landscaped grounds (formerly a squash court).

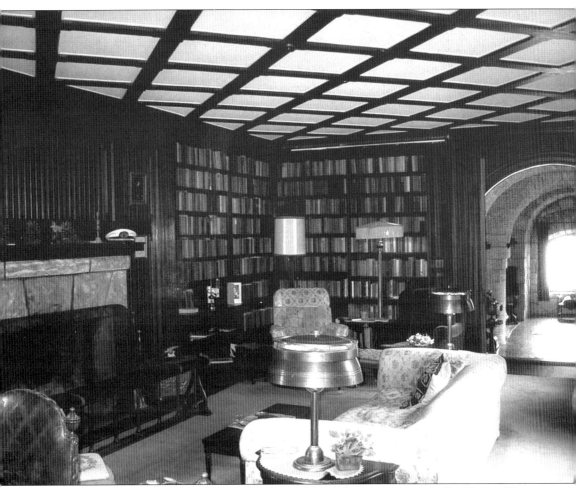

The other room on the ground floor, also accessed from the great room, is the library. This lovely wood-paneled room is 32 by 18 feet and features walnut-finished bookshelves from floor to ceiling. This picture shows a view from inside the library, looking back out at the arched pillars of the great room.

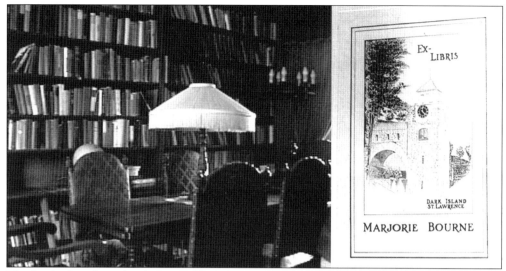

The books found on the shelves today represent the castle's entire history, including original owner Frederick Bourne, his daughter Marjorie and her husband, and the most recent owners, Harold and Eloise Martin. Many of the books can be identified by custom-made bookplates with the castle clock tower on them.

One of the items belonging to the castle's original owner was a mahogany-colored wooden folding desk with Frederick Bourne's initials on it. Bourne, president of the Singer Sewing Machine Company, probably had plenty of use for a folding desk in addition to a permanent office space in the castle. His wooden desk still remains in the library after over 100 years.

The castle has many hidden passageways, including one leading into the library. Next to the marble fireplace is a secret panel leading from the library to passages inside the walls. Many of the secret passageways had a very practical purpose. Servants could move from room to room to serve the guests without disturbing anyone.

Entering the library from the great room, one can pass directly through the library and on through another door that leads to yet another suite of rooms (15 by 24 feet and 18 by 7 feet). During the time of the original owner, when the guests came to play squash, this area was used as a changing room for the tired players (interestingly, Ernest Flagg's original designs described it as a storage room and the current library as a billiard room).

Recent owners used this area as a private study with a full bathroom. In the office space, a large brown envelope (upper left) was later discovered. Dated November 12, 1903 (when work began on the castle), it was hand-addressed from the designer Ernest Flagg to Frederick Bourne.

Next, visitors ascend the broad, splendidly proportioned spiraling granite stairs to the main floor. The journey is enhanced by highly polished carved oak balustrades and newel posts, and the walls are enhanced with works of art. The staircase eventually leads from the great hall to the upper drawing room, the formal dining room, the breakfast room, the loggia, and the sunroom.

The wood-paneled drawing room (36 by 36 feet) is also known as the trophy room. It is considered by many to be the showpiece of the castle. The room has a 20-foot ceiling and a large pink-marble fireplace.

The drawing room also features three cozy alcoves with Pullman window seats along the exterior wall, with river views and enclosed draperies for privacy. Just off the drawing room is a powder room with a fully functional Victorian-styled water closet, including an upper tank and pull chain. The powder room dates from the time of the original owner. (Courtesy of Farhad Vladi, Singer Castle.)

Upon entering the trophy room, visitors find their attention immediately drawn to the heads of several gigantic creatures mounted on the walls. The original owner, Frederick Bourne, was an avid hunter. Also, the castle was modeled after a hunting lodge and was used as one by Bourne in the fall (we do not believe he bagged any of these trophies on Dark Island).

"On other rusty fastenings were still displayed the hunting trophies of the monarchs to whom the lodge belonged and of the silvan knights to whose care it had been from time to time confided."—*Woodstock*, by Sir Walter Scott.

Pictured in a gilded-framed portrait overlooking the room is King Charles I (1600–1649), who took refuge in the Woodstock Park castle after which Singer Castle was modeled. What one might not realize at first glance is that the picture can be unhinged and swung open for viewing the room below from a secret passageway behind it. It is said that when the masons who worked on the castle had their first experience in the mysterious passageways, they were quite frightened and never came into the house after it was completed.

"Sir Henry Lee, undo me the secret spring of yonder picture of your ancestor. Nay, spare yourself the trouble and guilt of falsehood or equivocation and, I say, undo me that spring presently."—*Woodstock*, by Sir Walter Scott.

"Everard, by the assistance of a table and chair, examined the portrait still more closely and endeavoured to ascertain the existence of any private spring, by which it might be slipt aside—a contrivance not unfrequent in ancient buildings, which usually abounded with means of access and escape, communicated to none but the lords of the castle, or their immediate confidants."—*Woodstock*, by Sir Walter Scott.

Just off the drawing room is the aptly named Round Room, built into the turret. Facing south, it has several windows in its granite walls and offers spectacular views of the St. Lawrence River and the island below.

The Round Room is where the original owner, the busy president of the Singer Manufacturing Company, kept his vacation office. The large safe in the room belonged to Frederick Bourne and is one of the few items remaining in the castle that bear his nane.

Behind the drawing room is the comfortable loggia (36 by 20 feet), which features another huge stone fireplace. The room is furnished with several oversized antique sofas and a piano. It has often been used as the family sitting room and is particularly cozy on the cooler evenings when a hot fire is blazing in the fireplace.

In one corner of the loggia (the corner facing the drawing room), there is a small dial in the ceiling. This fully functional device is attached to the weather vane on the roof so that one need never leave the building to know which way the wind is blowing at Singer Castle.

The weather vane, located at the highest point of the tiled roof of the castle, has a letter B (for Bourne). Ospreys, which are members of the raptor family of birds, have occasionally made use of the weather vane over the years. This mother bird is carefully keeping watch over her rooftop nest.

Just past the loggia is the tile-floored 20-foot square sunroom (also called the wicker room). It features large picture windows on three sides and is filled with wicker furniture. It is the perfect place to sit and enjoy the cross breezes on a hot summer day.

LOGGIA, THE TOWERS

When the castle was first built, the loggia and the sunroom were combined. In the late 1920s, the owners separated the two rooms, completely enclosed the loggia, and added a fireplace. This postcard is from the time of Frederick Bourne's daughter Marjorie, who was responsible for the additions.

The other room that leads off the trophy room is the formal dining room (30 by 20 feet). This room features a marble fireplace, walnut-paneled walls, and three large doors leading to the outside terrace. The dumbwaiter from the kitchen on the floor below comes up to the butler's pantry off the dining room, which features sinks and warming ovens.

"When the house of Tudor acceded to the throne, they were more chary of their royal presence, and feasted in halls and chambers far within."—*Woodstock*, by Sir Walter Scott. This photograph dates from the early 1900s. (Courtesy of the St. Lawrence County Historical Association.)

Above the wood paneling on the upper wall of the dining room is a small, innocuous screen. Behind the screen is one of the many secret passageways that run horizontally and vertically at the mezzanine level and completely surround the drawing room. They are accessed via two spiral stone staircases.

Taken from inside the passageway, this photograph shows the perfect view one has of the room below. Secret passages can be found in nearly every room of the house and are entered from doors disguised as chimneys, wainscoting, or the wall of a bedroom closet. These hidden doors are opened by a variety of curious devices, including thermostats, push buttons concealed behind lighting fixtures, and even closet hooks.

One must pass through the formal dining room to get to the lovely breakfast room. Two separate doors (on either side of the fireplace) lead from the dining room to the breakfast room. When the castle was built, it did not include the breakfast room. (Courtesy of Farhad Vladi, Singer Castle.)

The breakfast room (37 by 20 feet) has an oak ceiling and carved beams. The large Gothic windows on three sides offer a panoramic view of the river. There is a large door leading to an outside balcony that overlooks the river. (Courtesy of Jean Devaughan.)

The breakfast room was added in the late 1920s by Frederick Bourne's daughter Marjorie. From the 1960s until the time of the newest owners, it was used as a music room or as a chapel, where weekly Sunday services were held throughout the summer months.

"Wildrake crossed through the under ward, or court, gazing as he passed upon the beautiful chapel. . . . 'I hope the time will soon come, sir, when Englishmen of all sects and denominations,' replied Everard, 'will be free in conscience to worship in common the great Father, whom they all after their manner call by that affectionate name.' "—*Woodstock*, by Sir Walter Scott.

Mounting another set of magnificent spiraling wooden stairs, one arrives on the upper floor, which features a large hall, the master bedroom, and five guest bedrooms. Once again, the journey up three spiraling turns to the second floor is enhanced with works of art on the walls.

There are five guest bedrooms on the second floor. One (16 by 14 feet) has a circular bath in the turret, with a spectacular view of the main shipping channel. Two other guest rooms (16 by 13 feet and 15 by 16 feet) are connected by French doors.

Two of the guest bedrooms (27 by 20 feet and 23 by 14 feet) have fireplaces and bathrooms. One of these, directly over the music room, was added in the 1920s, along with the music room. It has windows on three sides and has always been one of the favorite rooms used by guests. (Courtesy of Farhad Vladi, Singer Castle.)

The master bedroom (22 by 20 feet), which was added in the 1920s, has windows on three sides and a fireplace. It is a part of a self-contained living area that has its own kitchenette and a bathroom (23 by 14 feet) that includes a sauna with a French door and a massage room. It has carved doors and an archway. If the owners had a large number of guests and wanted some privacy, the master bedroom suite offered everything they needed for their own island getaway.

One of the most intriguing aspects of Singer Castle is its many secret passageways. One entry point is through a door at the top of the first-floor staircase. After ascending a circular stone staircase, one may peek down into the dining room before following the tunnels to the portrait hanging over the drawing room. "The fact was undeniable, that in raising the fabric some Norman architect had exerted the utmost of the complicated art . . . in creating secret passages and chamber of retreat and concealment. There were stairs which were ascended merely, as it seemed for the purpose of descending again; passages which after running and winding for a considerable way, returned to the place where they set out; there were trap-doors and hatchways, panels and portcullises."—*Woodstock*, by Sir Walter Scott.

Some of these passageways were designed with a functional purpose, allowing servants to move unobtrusively from room to room without disturbing family members or guests. The secret panels and passageways, as well as the dungeon located in the upper-floor turret (pictured here), were carefully patterned after those described by Sir Walter Scott in *Woodstock*. After passing through the dungeon, one will eventually find another set of descending stone stairs and can exit into one of the bedrooms. "And who expected to see anything said Bletson, excepting those terrified oafs, who take fright at every puff of wind that whistles through the passages of this old dungeon?"—*Woodstock*, by Sir Walter Scott.

Mounting yet another flight of stairs, one arrives at a dormitory-type room (30 by 22 feet) with a high cathedral ceiling, dormer window insets, and built-in cupboards. The room, which accommodates six single beds, was formerly used as a game room for table tennis. There are windows on all four sides and a few steps down to a lower bathroom.

From the fourth floor, a narrow circular stone staircase ascends up one more level to the tower room, or map room (16 by 16 feet). Featuring a fireplace and yet another bathroom, this room offers a marvelous view of the Thousand Islands in all directions. From this highest location, there are approximately 80 steps back down to main entrance.

Two

OUTSIDE THE CASTLE

Now that the inner wonders of the castle have been explored, the tour continues on to the remarkable exterior of the castle. This postcard dates from just after the 1920s, the time of Marjorie Bourne Thayer, when the additions were constructed.

Singer Castle is in the heart of the Thousand Islands region on Dark Island, located near the village of Chippewa Bay. This satellite view shows Dark Island (upper left) in relation to Chippewa Bay (lower right). The inset is a closeup of the island, which is 6.2 acres in size.

This photograph was taken from the northern side of the island. The view looks across the seaway and shows the castle (foreground) and some of the islands of Chippewa Bay. (Courtesy of Corbin's River Heritage.)

Singer Castle is a five-story granite masterpiece consisting of 28 rooms and 13 fireplaces. Unlike Boldt Castle (its well-known neighbor just down the river), Singer was completely finished and has been occupied throughout its more than 100-year history.

"They stood accordingly in front of the old Gothic building, irregularly constructed, and at different times, as the humor of the English monarchs led them to taste the pleasure of Woodstock Chase, and to make such improvements for their own accommodation as the increasing luxury of each age required."—*Woodstock*, by Sir Walter Scott.

Singer comes complete with stone spiral stairways, Spanish red-tile roofs, copper gutters, and towers. One of the most photographed features is the large front tower, or turret, after which it got its original name, the Towers. "The oldest part of the structure had been named by tradition Fair Rosamond's Tower; it was a small turret of great height, with narrow windows, and wall of massive thickness."—*Woodstock*, by Sir Walter Scott. (Courtesy of Farhad Vladi, Singer Castle.)

The front turret is as functional as it is impressive. On the various levels, visitors can find everything from a private office to exotic round bathrooms (on the second and fourth floors). There is even a castle dungeon (located behind the small narrow window just above the center of the picture).

When it was first completed, the castle was called the Towers. It was designed to have two towers: a large tower at the front, facing south, and a smaller tower, round with a conical roof, facing north. (Courtesy of the St. Lawrence County Historical Association.)

The smaller tower is just outside the northern entrance to the castle. This photograph was taken after the loggia and sunroom were separated. The master bedroom suites were built on top of them, making the wing on the west side taller than the castle's second tower.

The castle, like many of the structures built during that time, was constructed of granite stone quarried on neighboring Oak Island. The castle was built atop a solid granite rock foundation, all of which was also hauled over from the quarries.

The castle was completed in 1905, along with several other buildings. Some 20 years later, Frederick Bourne's daughter built additions to the original castle. This postcard dates from the early 1900s. (Courtesy of the St. Lawrence County Historical Association.)

Three

ADDITIONAL STRUCTURES

In addition to the castle itself, the Dark Island property consists of several other buildings, all of which were constructed at the time the original castle was built. Structures included a clock tower, a caretaker's cottage, an icehouse, and two large boathouses.

The five-story granite clock tower has winding stairs that rise to the self-regulating electric clockworks. The tower was built at the same time as the castle, but the fifth floor and clock were added later. One can enter the clock tower through a door and spiral staircase leading from the castle's kitchen area.

The clock and its fifth-floor tower were added by Frederick Bourne's daughter Marjorie more than 20 years after the castle was built. The clock was designed by the E. Howard Clock Company, which was one of the first companies to make electric clocks, at the beginning of the 20th century. It was made with Westminster chimes and is valued in excess of $75,000.

The four wrought-iron clock faces are each 12 feet in circumference. The six-foot-long hands on all four sides are easily viewed from the breakfast room and its balcony. When the clock was installed in the late 1920s, it ran on an old direct-current system. Dr. Harold George Martin converted the clock so that alternating current (supplied by the Niagara Mohawk Power Corporation) could be used.

Thanks to Harold Martin, the clock and its chimes are still fully functional today. The chimes can be heard across the water by those in many passing boats and by the nearby islanders.

BOAT HOUSE AND DOCK, THE TOWERS

"He heard the bells of Woodstock church ring curfew, just as he was crossing one of the little meadows we have described. . . . The bell of the lodge was ringing at that dead hour of the night as hard as ever it rung when it called the court to dinner."—*Woodstock*, by Sir Walter Scott.

The castle has two fully enclosed boathouses. The clock tower connects the castle with the south boathouse (42 by 100 feet), which is large enough to house a 90-foot steam yacht. It was used for this very purpose by its original owner.

BOAT HOUSE INTERIOR, THE TOWERS

The south boathouse has two slips. Outside the boathouse, there is an additional slip where another large boat (or a few smaller boats) can dock. One of the boathouse's two doors opens onto a brick path that leads to the main door. The other door opens to an inside staircase that ascends several flights and leads to the castle through the kitchen area.

In inclement weather, one can pass from this boathouse into the castle by way of a long tunnel. "What sort of a house is Woodstock, said the General, abruptly. An old mansion said Wildrake in reply; And, so far as I could judge by a single night's lodgings, having abundance of back-stairs, subterranean passages, and all the communications under ground which are common in old raven nests of the sort."—*Woodstock*, by Sir Walter Scott.

The dock at the north boathouse is 15 feet wide and 250 feet long. This boathouse (featuring an 18- by 125-foot slip) features screw jacks designed to raise a 100-foot yacht for winter storage. Pictured is one of the original owner's yachts. (Courtesy of the St. Lawrence County Historical Association.)

The north boathouse also has a large workshop with power tools and generators formerly used to generate power for the island. Power is now supplied by Niagara Mohawk via underwater cables. The boathouse includes an electrical room, water pumps, and a fire pump. On the second floor are nine bedrooms, two bathrooms, a living room with a fireplace, and a large dining room. The building is constructed of stone, and the entire ceiling over the slip is original wainscoting. The ceiling has a vent pipe that was originally used for the steam yacht.

Built of solid stone, the caretaker's cottage (side and front view pictured) is fully insulated and heated. The island is protected and maintained year-round by a full-time caretaker. Not far from the caretaker's cottage is a two-story icehouse.

VIEW FROM DOCK, THE TOWERS

The beautifully landscaped grounds include a stone path ascending from the south boathouse to the main entrance of the castle. A turret-styled granite sitting area halfway up the path offers a striking view of the St. Lawrence Seaway's main shipping channel in both directions.

PERGOLA, THE TOWERS

The grounds also feature a 25- by 54-foot squash court built of solid granite. The court was added by Marjorie Bourne, whose husband, Alexander D. Thayer, was a competitive athlete. There are also extensive lawns, walking paths, and a pavilion. The pavilion, also called the pergola, is paved with brick and has an eastern view of the St. Lawrence River.

On the west end of the island is a protected swimming beach. On the east end (pictured), the yacht basin boathouse provides storage space for smaller boats and can even accommodate a seaplane.

The castle and its related buildings are said to have cost $4 million to build. Constructing such an architectural wonder today would cost about $40 million.

Four

THE SINGER SEWING
MACHINE COMPANY

The Gilded Age (1890–1910) got its name from the many great fortunes created during this period and the way of life this wealth supported. It was during this time that a preacher's son in his early 30s worked his way up to become president of one of the most successful manufacturing companies in the world. Through the wealth generated by the company's success, Frederick G. Bourne eventually purchased Dark Island.

The Singer Manufacturing Company is the most famous sewing machine manufacturer in the world. The company was founded by Isaac M. Singer, who was born in Schaghticoke in 1811.

Isaac Singer was the inventor of the first practical continuous sewing machine. While working with a tool manufacturer in Virginia, he came across a sewing machine in need of repair. He studied the machine and decided it was clumsy and unreliable. He knew he could build a better machine himself, and within 11 days, he had produced his first prototype. Singer took out his first sewing machine patent in 1851.

While Isaac Singer was a talented inventor, he was never known for his ability to run a successful business. That is where Edward Clark came in. Despite their many personal differences, Singer asked Clark to become his business partner. As one historian described it, "a lasting, and less likely partnership developed between the near-illiterate and amoral Isaac Singer and one Edward Clark, a graduate of Williams College, attorney and Sunday School teacher."

Despite the company name being Singer, it was actually Edward Clark who made the Singer Manufacturing Company into a phenomenal conglomerate that helped change the face of business in America.

Edward Clark went to college and taught Sunday school but lacked any formal training in merchandising. Nevertheless, he became one of the most astute businessmen in the country. With a promotional program that consisted in part of pretty young women demonstrating sewing machines in elaborately decorated showrooms, Clark overcame the prevailing prejudice against allowing women to operate machinery.

The First Practical Sewing Machine—1851

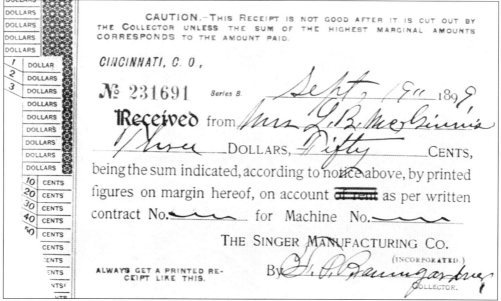

It was under Edward Clark's leadership that Singer became the first business to implement the selling of service contracts along with each sewing machine. Clark was also instrumental in pioneering the installment plan in 1856, with the introduction of the Singer family model sewing machine. The retail price of the sewing machine was far above what the average family could afford, so an installment plan placed the Singer sewing machine within the means of the average household.

Despite their great success as a business team, Isaac Singer and Edward Clark continued to have their differences. By 1863, Singer was surrounded by scandal, and Clark, the conservative business partner, was so disgusted that he dissolved the 12-year partnership. An independent corporation was formed, with Isaac Singer outside of the company's day-to-day operations. Clark named Inslee Hopper as the first president but retained de facto control of the company.

Isaac Singer died in 1875 at the age of 63. In 1876, Edward Clark took over the presidency. After Clark's death in 1882, George McKenzie became president and served until 1889. During that time period, Singer's widow, Isabella (30 years younger than Singer), is rumored to have been the model for Bartholdi's Statue of Liberty, which was given to the United States in 1884.

George McKenzie remained president of Singer until his death in 1889. At that time, the 32-year-old Frederick G. Bourne (pictured at a later age) became the company's fourth president.

Under Frederick Bourne's talented leadership and innovative ideas, the Singer Manufacturing Company grew and prospered, opening offices and manufacturing facilities all over the world.

In 1893, the Singer Manufacturing Company had a set of postcards made up and packaged in sets as souvenirs of the World's Columbian Exposition. The postcards were an attempt to show the worldwide success of the Singer sewing machine. The text on the package states, "These cards are lithographed reproductions of photographs taken on the spot in the various countries and provinces and colored there to correctly represent the native costumes. They are national costume studies, reliable and perfect in every detail."

On the back of each promotional postcard is a description of the nation it represents: the location, commerce, religion, other interesting national features, and, of course, style of dress worn—no doubt sewn on a native Singer sewing machine.

An example of one of the postcards, Tunis (lower right), reads, "One of the Barbary States of North Africa. Bounded North and North-west by the Mediterranean, South-east by Tripoli, South and South-west by the Sahara, West by Algeria. . . . Tunis, the Capital City, built at the head of a lagoon connected with the Bay of Tunis, is a city of great antiquity, and is but three miles from the site and ruins of the ancient city of Carthage. For many years the Tunisian pirates were the scourge and terror of the marine of the world. Our picture represents a Tunisian woman in her peculiar dress, resting her hand upon the woman's faithful friend the world over, our 'Singer' which has its place in multitudes of Tunisian homes."

THE SEWING MACHINE AND KNITTING MACHINE

SAVING WOMAN'S LABOR AND LESSENING EXPENDITURE.

BEFORE THE TIME OF THE SEWING MACHINE.

HOW SEWING IS DONE TO-DAY.

As a result of Frederick Bourne's expansion of the company, the Singer sewing machine became a common item in households around the world, the Singer Manufacturing Company became one of the most successful conglomerates in the world, and Frederick Bourne became one of the wealthiest men in America.

Pictured are two *c.* 1905 Singer sewing machine models. Singer introduced the first practical electric sewing machine in 1889. By 1905, the electrically powered sewing machine was in wide use. Also in 1905, Frederick Bourne announced his early retirement, to the surprise of his company's shareholders. Typical of Bourne and his leadership skills, however, the passing of power transpired smoothly since he had thoroughly groomed his successor, Douglas Alexander, to assume the presidency.

TITCHING AND EMBROIDERY

were the chief accomplishments of ladies in the Feudal Age. Singer's inventions, and their development by his successors, have since made the art of sewing common to all. That the value of the sewing machine as **a means of refinement** is exceeded by the printing press, may be an open question—but no question exists as to the superior excellence of

Singer Machines
——For Family Sewing——

Your choice of Three Distinct Types.

The Singer No. 15

**Double Lock-Stitch.
Oscillating Shuttle.**

The Dressmaker's Machine; especially adapted for high-speed operation, producing greatest quantity of fine stitching, and requiring least effort by the operator. Has unusually large bobbin for lower thread and finest mechanical adjustment. Greatest range of work and lightest-running lock-stitch machine in the world.

The Singer No. 24

**Automatic
Chain-Stitch.**

Guaranteed to be in every point the best single-thread chain-stitch machine on the market. The general advantages of this type of machine for family sewing comprise greatest ease and quietness of operation, simplicity of construction and elasticity of seam.

The Singer No. 27

**Double Lock-Stitch.
Vibrating Shuttle.**

More generally used for family sewing throughout the world than all other machines combined. The movement of the self-threading vibrating shuttle being shorter than in any other similar machine, less effort is required for its operation.

Made and sold only by THE SINGER MANUFACTURING CO. **Offices in every city in the world.**

This *c.* 1905 Singer advertisement—complete with knights, armor, and towers—appeared in *Harper's* around the time the work began on Frederick Bourne's castle in the Thousand Islands.

After a 16-year term, 54-year-old Frederick Bourne stepped down from the president's office at the shareholders' meeting in 1905. When he retired, company assets approached $90 million and employment included 30,000 factory employees and an estimated 60,000 others in various positions in branch offices globally. It has been estimated that Singer company production levels at the time were as much as three million machines a year. Bourne remained one of the company directors until his death 14 years later.

Five

FREDERICK BOURNE
BUSINESS AND PLEASURE

Frederick G. Bourne, who eventually became one of the richest men in the world, was not born into a wealthy family but, instead, came from the humble background of being a minister's son. Bourne's life took a much different path from that of his upbringing, eventually working his way from minister's son to millionaire. (Courtesy of the Clements Library, University of Michigan.)

Frederick G. Bourne was born on December 20, 1851, to Rev. George Washington Bourne and Harriet Gilbert Bourne, who were New Englanders of very modest means. In that same year just down the road in New York City, Isaac Singer built and patented his first sewing machine.

While Frederick Bourne was still young, the family moved to New York City. Since he did not have enough money to go to college, he went to work instead and began his professional career as a clerk in New York City's Mercantile Library.

TRINITY CHURCH, NEW-YORK.

In his spare time, Frederick Bourne enjoyed singing in his church choir at Old Trinity Church (known worldwide today as the church that remained standing after the World Trade Center towers collapsed on September 11, 2001). Alfred Clark, son of Singer president Edward Clark, sang in the same choir as Bourne. After Edward Clark's death in 1882, Alfred filled his father's seat on the board of directors and began to send the business-minded Bourne to attend the company meetings as his proxy. Bourne quickly began climbing the corporate ladder. He eventually worked his way up to vice president and, in 1889, assumed leadership of the company as president.

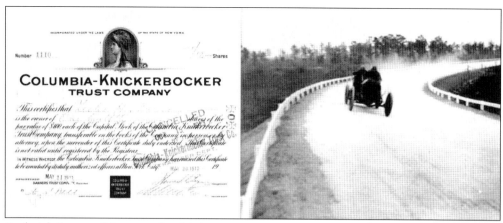

Frederick Bourne did not confine his business interests to sewing machines. In fact, he became involved in a wide variety of businesses such as the Knickerbocker Trust Company (Bank of New York), of which Samuel L. Clemens (Mark Twain) was also an investor during that same time period. Bourne also invested in the Long Island Motor Parkway and was one of its directors from its inception in 1906, due in part to his own driving skills.

Bourne's business interests also included the Atlas Portland Cement Company, which was at the forefront of using concrete for residences. He was also an investor in the Long Island Rail Road, which was chartered in 1834 and was completed in September 1910. The railroad became part of the Metropolitan Transport Authority in 1965.

Frederick Bourne's involvement in the Aeolian Company led to the purchase of his own private organ. In 1907, he enlarged the music room on the east side of Indian Neck Hall to accommodate the largest organ ever purchased for a private home. The room was 40 by 100 feet, and the organ contained over 7,000 pipes costing well over $100,000.

The wealthy Bourne acquired quite a bit of real estate for himself, including several thousand acres reaching to West Sayville. He also owned the entire first floor of New York City's legendary Dakota building.

Despite his apparent Midas touch in the business world, Frederick Bourne had outside interests that far surpassed those of his business ventures. He was a consummate sportsman who enjoyed a wide range of sports. He was an avid yachtsman, a skilled billiards player, and a fisherman, hunter, and bowler.

Bourne was also a skilled boxer. In his younger days, his instructor at the New York Athletic Club, Mike Donovan, considered Bourne to be one of his best heavyweights. In his best days, he was even chosen to go a few rounds with John L. Sullivan, the world heavyweight champion.

Frederick Bourne also spent a great deal of time and money raising horses. His prizewining horses included Enthorpe, Performer, Starlight, Princess Olga, Indian Queen, Priscilla, Tomahawk, Jennie Neil, and His Grace. By the end of the 1890s, Bourne brought home many ribbons from the national horse show in New York. Pictured are Bourne's horse stables at his Oakdale estate.

Bourne was the first in the area to own an automobile and was a skillful driver. As he became more skilled, he imported a number of expensive European cars, for which he had a garage built near his stables in 1901. He was often seen driving his $10,000 Mercedes around the Oakdale area in the early 1900s.

Without a doubt, first among Frederick Bourne's many interests was boating. Bourne owned numerous costly pleasure crafts, ranging from small speedboats to large steam yachts. Some of his better known yachts included the *Delaware*, the *Colonia*, and the *Artemis*. The *Alberta*, a yacht Bourne purchased in 1914, was over 300 feet long and required a crew of 55 men. At one time, it was chartered by the South American explorer Dr. Alexander Hamilton Rice, who used it in his exploration of the Amazon. Pictured is Bourne's yacht *Dark Islander*. (Courtesy of Corbin's River Heritage.)

Needing a place (or places) to keep all his pleasure craft, Frederick Bourne became a member of several yacht clubs in the area, including the Sewanhaka-Corinthian Yacht Club and the New York Yacht Club (pictured), where he was named vice commodore in 1902 under commodore Lewis C. Ledyard.

FREDERICK G. BOURNE, COMMODORE OF THE NEW YORK YACHT CLUB.

Bourne was named commodore of the New York Yacht Club in 1903 and served until 1905. His steam yacht *Delaware*, which was purchased in England, was the flagship of the yacht club during most of his term as its commodore. The *Delaware* was 350 feet long and had a crew of more than 100 men. (Courtesy of the Clements Library, University of Michigan.)

Frederick Bourne also became a member of the exclusive Jekyll Island Club in Georgia, of which was written, "Here anchored the most luxurious pleasure craft in the world." By the early 20th century, Jekyll Island members were said to represent one-sixth of the world's wealth. Pictured is the *Robert E. Lee* docked at the Jekyll Island dock. Bourne owned his own apartment and docked his own palatial yacht *Marjorie* there. (Courtesy of the Richard and Gini Steele Collection.)

J. P. Morgan, a close friend of Bourne, kept his yacht *Corsair II* at Jekyll Island. The *Corsair II* was 304 feet long. When asked how much it cost, Morgan famously remarked, "If you have to consider the cost you have no business with a yacht." Other yachts owned by prominent Jekyll Island Club members included Pierre Lorillard's *Carmen*, James Stillman's *Wanda*, the Astors' *Nourmahal*, Cornelius Vanderbilt's *Valiant*, and Joseph Pulitzer's *Liberty*.

Six

FREDERICK BOURNE
FAMILY AND FAITH

On February 9, 1875, Frederick Bourne (back row, right of center) married Emma Sparks Keeler (next to Bourne, on the right) of New York. The couple's first child, Arthur, was born on October 7, 1877. Eight more children followed: Alfred, George, Florence, Marion, Marjorie, May, Kenneth, and Howard. (Courtesy of Deborah Lack, Singer Castle.)

Frederick and Emma Bourne's two youngest boys, Kenneth and Howard, died during their parents' lifetime. Kenneth died on Christmas Day 1898 at the age of seven. On Christmas in 1901, Frederick Bourne presented St. Ann's Church in Sayville with a gift of $5,000 in memory of his son.

In 1897, Frederick Bourne began work on his massive 110-room summer residence, Indian Neck Hall, on the east side of Oakdale. Oakdale has been described as "a scion of America's gilded age of a century ago, where powerful men of incredible wealth built South Shore gold coast mansions and dwelt in manorial splendor."

Indian Neck Hall, with its nearly 1,000 acres, was considered by many to be the most lavish of the estates in the area. It was designed by world-famous architect Ernest M. Flagg (1857–1947), a business associate and friend of Frederick Bourne.

The mansion was completed in 1900, in time for Frederick and Emma Bourne to celebrate their 25th wedding anniversary at their new country residence. This was one of the first of many social events held by the Bournes at their Oakdale estate.

Boating Dock, Sayville, L. I

Even with all his wealth, Frederick Bourne had his priorities in place. He would often arrive on Sunday at the town dock in one of his speedboats. Upon his arrival, boys from the area would often be waiting for him. Bourne would ask them if they had gone to Sunday school and would then tell his driver to take them out for a spin in the boat while he went on to church.

Bourne was noted to be a highly principled leader who never veered from the ideals ingrained in him since childhood. This was demonstrated in how he handled his great wealth. He gave great amounts of money and real estate to charity. Around 1890, Bourne joined the Sayville Fire Department. In 1916, he presented the department with its first motorized fire truck, made by the Reo Motor Car Company.

The F. G. Bourne Gate Lodge, Oakdale, L. I.

The Bournes were generous in many other ways, much of which went unrecorded since they made many of their donations anonymously to avoid the publicity. When the house of an elderly blind couple in West Sayville was destroyed by fire in 1905, Bourne stepped in and presented the couple with a replacement. He gave them the eastern gatehouse of his own estate and had it moved to their property at his expense.

When the railroad station in Oakdale needed improvements, Bourne contributed half the money needed to make them. He gave $500,000 to the Cathedral of St. John the Divine in 1914 as an endowment fund for a choir school. During World War II, Bourne was a generous contributor to the Red Cross, giving $100,000 in 1917 and another $25,000 in 1918. That year, he also gave $40,000 to Hope Farm (pictured), a rehabilitation home for children.

In 1926, Bourne's estate was purchased by the LaSalle Christian Brothers, a Catholic order, and became the home of the LaSalle Military Academy. The military and parochial school closed its doors in June 2001 after 120 years. It was to this same organization that Bourne's daughter Marjorie later gave the castle on Dark Island.

Frederick Bourne was the director of the New England Society of New York, a religious group that was responsible for erecting the well-known statue *The Pilgrim*. The Pilgrims had sailed to America in search of religious freedom. As one commentator wrote, "Bourne best exemplified the spirit of teamwork and cooperation that the early Pilgrims brought to their chosen land" in the way he managed both his business and his personal life.

Frederick Bourne served as the president of the exclusive Jekyll Island Club from 1914 to 1919. Even there, he was recognized by his peers as a man of faith. He and other members contributed to the construction and establishment of their own place of worship on Jekyll Island. Faith Chapel is pictured on the far right. (Courtesy of the Richard and Gini Steele Collection.)

The famous Faith Chapel was built in 1904. Its construction, both interior and exterior is tidewater red cypress shingle. The chapel was dedicated in 1904 as an Episcopalian place of worship, but leaders of the church held out their hands to visitors of other beliefs. The chapel on Jekyll Island remains in use today.

Frederick Bourne's involvement in Faith Chapel is still evident today. The chapel contains one of only four signed Louis C. Tiffany stained-glass windows in the country. Installed in 1921, the exquisite window portrays the theme *David Set Singers before the Lord* and was dedicated in memory of Frederick Bourne, who died in 1919. (Courtesy of John Hunter, chief curator, Jekyll Island Museum.)

Anyone familiar with the name Frederick Bourne quickly grasped the allusion being made in the window's theme to both Bourne's position as president of the Singer Sewing Machine Company and his involvement in the chapel. Bourne was a regular member of the Faith Chapel choir. (Courtesy of John Hunter, chief curator, Jekyll Island Museum.)

Seven

THE TOWERS

Dark Island
Chippewa Bay N.Y.

It should have come as no surprise when, in the late 1800s, Frederick Bourne—commodore, private yacht club president, millionaire, avid boater, and ardent hunter and fisherman—decided to purchase his own private island in the Thousand Islands area with the intention of building himself a hunting lodge. What did come as a surprise, even to his own family, was the kind of "hunting lodge" he decided to build.

Although he never revealed his plan for the building on Dark Island, those who knew Frederick Bourne must have had some idea what scale he had in mind when he commissioned famous architect Ernest Flagg (pictured) to accomplish the task of designing his island getaway. Bourne and Flagg were known to be friends in addition to business associates.

Ernest Flagg designed two buildings for the Singer Manufacturing Company, but he was also responsible for the Chrysler Building, the Washington Cathedral, the Corcoran Gallery of Art, and the chapel at the U.S. Naval Academy, Annapolis (pictured).

NEW YORK, SINGER BUILDING.
Broadway corner Liberty Street.
Highest Building in the World
41 stairs.

Ernest Flagg had already designed two buildings for the Singer Manufacturing Company when, in 1906, the company declared it would build the world's tallest building. Flagg achieved the company's goal, designing a building that soared to a height of 612 feet. In 1908, the Singer Building was opened, and it became the headquarters of Singer for the next 54 years. Hence, it was only logical that Singer president Frederick Bourne would approach Flagg with the project he had in mind for Dark Island.

Coincidentally, when Bourne asked Ernest Flagg to design an island hunting lodge, Flagg had just finished reading Sir Walter Scott's *Woodstock* (1832), a historical novel set in England in 1652.

In *Woodstock*, the entire story revolves around a mysterious castle with secret passageways used to protect the ousted King Charles (1600–1649) from the independents led by Sir Oliver Cromwell (1599–1658). Since the castle described in Scott's tale was a hunting lodge, it was quite logical to Ernest Flagg and Frederick Bourne that the castle on Dark Island should be patterned after the one that had stood in Woodstock Park (near Oxford, England) during the reign of England's Charles I. Pictured is *Cromwell at Whitehall*, a 1896 print.

Apparently, Frederick Bourne shared Ernest Flagg's enthusiasm for historic English castles. In 1893, Bourne had a tapestry created for the Singer Sewing Machine Company's exhibit at the World's Columbian Exposition in Chicago. In addition, he had a Singer chromolithograph done by the J. Ottman Lithograph Company of New York City to be given out to visitors of the Singer exhibit at the exposition. Entitled *The Knighting of the Earl of Warwick*, the lithograph had a history of its subject on the reverse side.

OAK ISLAND QUARRY

Construction on the castle was begun in 1903 by the J. B. & R. L. Reid Company of Alexandria Bay. A total of 90 stonemasons worked on the project. Workers were employed from both America and Canada. In addition, Italian stone craftsmen were hired to shape the rose granite that would be quarried on Oak Island a few miles away at a cost of $500,000. At the time, Oak Island had a quarry that supplied the massive amounts of granite needed for the construction of Frederick Bourne's castle. (Courtesy of Roger Lucas.)

Both the workers and the granite moved just a few miles down the river after work was finished on Boldt Castle. In 1895, George Boldt purchased Hart Island in Alexandria Bay. In 1899, he began to build the castle that would capture the hearts of the world.

Although Boldt Castle has attracted far greater crowds than Singer Castle has, Frederick Bourne (right) attained far greater wealth than did George Boldt (left). Boldt put much of his wealth into the construction of his castle. Bourne, on the other hand, was only adding to his many other buildings and properties.

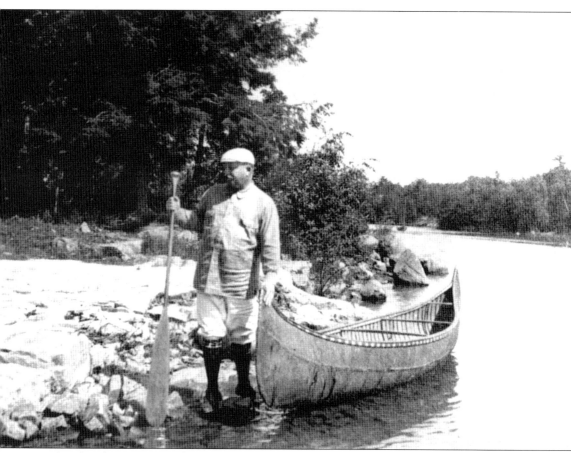

Another famous personality living in the area at the time the work began on Dark Island was Frederic Remington (1861–1909). Remington, who was born in Canton, had become quite well known worldwide as a Wild West artist. He, too, had purchased an island in Chippewa Bay. Remington's Island, Ingleneuk, was at the outer extremity of the bay, located in the Cedar Island cluster of islands just across the main shipping channel from Dark Island. He came to his island every summer from 1900 to 1908. (Courtesy of the Frederic Remington Art Museum, Ogdensburg.)

Frederic Remington loved his secluded island escape and referred to it as his "fortress of rest." Since he considered his island his own personal retreat from the world, he was not at all pleased when the construction of Bourne's fortress began. In Remington's mind, the neighborhood was spoiled. He would sit on his porch and scowl at the pretentious castle as it was being built. He did take a little time out from scowling to complete this untitled painting of the disruptive castle being built just across the river. (Courtesy of the Buffalo Bill Historical Center.)

The first building completed on Dark Island was the north boathouse, which was on the Canadian side of the island. The generator room was built early in the process to provide the power needed for the construction of the castle and other structures. This picture shows the construction work *c.* 1904. (Courtesy of the St. Lawrence County Historical Association.)

This view of the castle under construction was taken from the west end of the drawing room, looking toward the dining room and the doorway to the balcony. One can see the framework for the ceiling of the great hall. Above is a stud wall for part of the secret passageway. (Courtesy of Ralph Berry.)

Winter and summer, materials were hauled to this island that still had on it relics left by those who knew it as Lone Star. Workers discovered Native American grinding stones, arrowheads, spearheads, and flints. Also, War of 1812 relics such as a handmade pewter spoon and coins were found in the headland waters. (Courtesy of Corbin's River Heritage.)

"The challenges involved in completing this extraordinary project were difficult even in the way of transporting men and materials . . . realized by sight of the plant the contractor had to set up. . . . He bought an old canal boat and built a house on top of it with living quarters for his men at one end and a complete steam woodworking plant at the other end."—the *New York Times*, 1905. (Courtesy of the St. Lawrence County Historical Association.)

Pictured are three of the original blueprints drafted in Ernest Flagg's own handwriting. The ground floor (top) includes the main entrance into the great hall. The first floor (lower left) includes the drawing room and dining room. The second floor, or mezzanine (lower right), includes the top of the drawing room (which has a 17-foot ceiling) and several of the bedrooms. (Courtesy of Ralph Berry.)

In addition to the blueprints, Ernest Flagg made several detailed drawings of both the exterior and interior of the castle. On the left is the handwritten first page of Flagg's exterior design. On the right side is the first page of his interior design. (Courtesy of Ralph Berry.)

Frederick Bourne purchased land on the Canadian side of the river to provide topsoil for the castle grounds and gardens. Two 20-foot-long stone walls were built from the island's rocky surface, and 2,000 loads of soil from the Ontario property were dumped into the area between the walls, creating the level ground on which the squash court was eventually built. The *New York Times* reported, tongue-in-cheek, "This is probably the first and greatest actual 'annexation' of Canada ever achieved by the United States." Bourne also annexed another bit of Canadian land by purchasing nearby Corn Island, lying a half-mile away toward the north in Canadian waters.

While the stonemasons cut the pillars and arches, circular cantilevered stairs, turrets, and flying buttresses, other artists were hard at work crafting the beautiful wood paneling and wrought iron. Meanwhile, the specialists in tiling the roofs were making not only the tiles to cover the enormous roofs but also the tiles decreasing in size to cover the peaks atop the turrets. While all this construction was taking place, Frederick Bourne—the "Old Fisherman," as his family fondly referred to him—simply told them all that he was having a hunting lodge built in the Thousand Islands, never mentioning that it was a castle. (Courtesy of the St. Lawrence County Historical Association.)

More than two years after the project began, the castle was completed at a cost of nearly $500,000. In 1905, Frederick Bourne chartered a train to carry his family, friends, and servants from the family estate on Long Island to the town of Hammond. Pictured c. 1900 is the Hammond railroad station. (Courtesy the Hammond Historical Museum.)

From the railroad station, Frederick Bourne's family was driven through "downtown Hammond" and on down to the river's edge. They were transferred to one of Bourne's luxury boats, from which they soon saw, for the first time, Bourne's "hunting lodge."

Since the castle cannot be seen from the shore because of intervening islands, it was not until the boats came out from behind Cedar Island that the passengers could fully appreciate the extent of what that hunting lodge was. This aerial photograph was taken by Dwight Church over the mainland near Chippewa Bay.

"Dark Island" owned by Commodore Bourne of New York, Thousand Islands, N. Y.

We can only imagine the awe that Frederick Bourne's family experienced when they first saw the unbelievable sight of an authentic English castle in the St. Lawrence Seaway. This is one of the earliest postcards of the castle. It represents the view the astonished family members saw.

When the castle was completed, Frederick Bourne called his castle the Towers (reminiscent once again of *Woodstock*). The castle was the summer home and fall hunting lodge of the Bourne family until after Frederick Bourne's death. Bourne, his wife, his children, and a constant flow of guests spent their summer months on the river. A number of different boats, such as this steam yacht, were also kept there. (Courtesy of Corbin's River Heritage.)

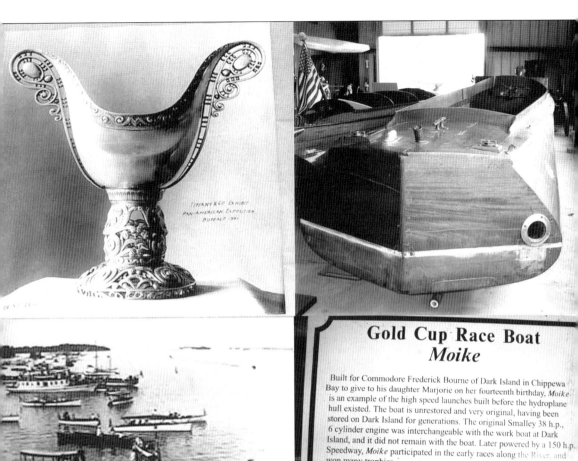

Gold Cup Race Boat
Moike

Built for Commodore Frederick Bourne of Dark Island in Chippewa Bay to give to his daughter Marjorie on her fourteenth birthday, *Moike* is an example of the high speed launches built before the hydroplane hull existed. The boat is unrestored and very original, having been stored on Dark Island for generations. The original Smalley 38 h.p., 6 cylinder engine was interchangeable with the work boat at Dark Island, and it did not remain with the boat. Later powered by a 150 h.p. Speedway, *Moike* participated in the early races along the River, and won many trophies.

Year: 1904 L.O.A. 36' 9" Beam: 4' 2"
Builder: Charles L. Seabury and Co. Engine: None
Accession Number: 72.025 Donor: Frederick B. Hard

Frederick Bourne was an avid boater. In the early 1900s, with the development of motorboats, he even became involved in competitive speedboat racing. In 1904, he purchased a high-speed 36-foot, 38-horsepower launch for his daughter Marjorie on her 14th birthday. (The Gold Cup races were held in the Thousand Islands in 1905.) The *Moike* is still on display at the Antique Boat Museum in Clayton.

Frederick Bourne died on Sunday, March 9, 1919, at Indian Neck Hall at the age of 68, just two and a half years after his wife died. His physician, Dr. George S. King of Bay shore, said that Bourne's death was from exhaustion and uremic poisoning. (Courtesy of the Clements Library, University of Michigan.)

Frederick Bourne's funeral was held at Indian Neck Hall. It was conducted by Bishop Greer of the Protestant Episcopal church and was attended by many prominent friends and associates, including J. P. Morgan, Cornelius Vanderbilt, and William Rockefeller. The choir of St. John the Divine came by train to sing at the funeral, accompanied by their organist, who played Bourne's huge Aeolian organ for the ceremony.

Bourne's body was transferred to the family mausoleum at Greenwood after the ceremony. Even in death, Bourne did not forget his favorite charities, leaving over $350,000 to various churches and charitable organizations. "But here am I seated, perhaps for the last time, with my Bible on the one hand and old Will on the other, prepared, thank God, to die as I have lived."—*Woodstock*, by Sir Walter Scott.

At the time of Frederick Bourne's death, his holdings amounted to nearly $42 million. His will was the largest ever settling in Suffolk County up to that time. He left the castle to his children. Three sons and four daughters survived him: Arthur, Alfred, and George Bourne; Mrs. Ralph Strassburger; Mrs. Anson Hard; and Marion and Marjorie Bourne. The youngest son, Howard, died in New Zealand just a few months prior to Bourne's own death. Court battles began as members of the family argued over the value and ownership of the castle. It was one of his daughters, Marjorie, who finally took possession.

INDIAN WALK, THE TOWERS

In 1926, Marjorie Bourne married Alexander D. Thayer, a stockbroker from Pennsylvania. In his youth, Thayer was an exceptional athlete, playing quarterback and center field at the University of Pennsylvania. He served in World War I as an aviation instructor. The Thayers continued to go to the island for a few weeks every year until Marjorie's death. This postcard, dating from the time of the Thayers, shows Indian Walk, one of the lovely walking paths on the island.

Although not as wealthy as Frederick Bourne, the Thayers were quite well off. In 1929, Alexander joined Marjorie as a member of the Jekyll Island Club, where they owned their own cottage. Pictured is the castle prior to several of the costly additions Marjorie built. One of their steam yachts (evidenced by its large pipe) is docked at the south boathouse. (Courtesy of the St. Lawrence County Historical Association.)

BREAKFAST ROOM, THE TOWERS

In the late 1920s, Marjorie Bourne Thayer and her husband had several additions built onto the castle, including the fifth-story clock tower and the lovely large breakfast room. The breakfast room was later used as a chapel and, most recently, was converted back to a breakfast room.

UPPER LOGGIA, THE TOWERS

It was also Marjorie who separated the sunroom from the loggia, fully enclosed the loggia, and added the second-floor master bedroom suite over them both (overlooking the squash courts). The sunroom looks virtually the same today, right down to the wicker furnishings, and is sometimes referred to as the wicker room.

Shown are "before" and "after" pictures of the castle. Note the additions of the master bedroom, built over the formerly combined open loggia and sunroom area (upper left), and the breakfast room (upper right). Also note the addition of the fifth-story clock tower below the structure's original rooftop.

In 1913, Marjorie Bourne Thayer gave her father two books written by J. H. Jowett. She kept those books in the castle library. Note her own handwriting, "To father—from Marjorie." Interestingly, Jowett writes, "In the lower reaches of the city there is the river, on which boats are plying for pleasure and recreation. . . . A little higher there is the castle hill, on which the turreted tower presents its imposing front; but on a higher summit . . . towers aloft the majesty of the glorious old cathedral. . . . In whatever prominence these may be seen, they are all to be subordinate to the reverence and worship of God."

Marjorie Bourne Thayer owned the castle on Dark Island for over 40 years, making her the castle's longest owner to date in its 100-year history.

Eight

THE POST-BOURNE YEARS

In the late 1950s, Marjorie and Alexander Thayer deeded the castle to the Christian Brothers for $1. This photograph was taken by Dwight Church.

Dark Island and its castle were willed to the LaSalle Christian Brothers and Military Academy of Long Island, to whom the family estate had also gone, with the understanding that Marjorie Bourne Thayer would have use of the property during her lifetime. She died just a few years after deeding the island and the castle to the Christian Brothers, giving them full possession in 1962. (Courtesy of the De LaSalle Christian Brothers.)

Between the high costs of maintenance and the short season it could be used each year, the LaSalle Christian Brothers could not find suitable use for the island castle. They put it up for sale. The castle is seen here as it spent the majority of the year while it was owned by the LaSalle Christian Brothers: closed and boarded up.

Interestingly, the castle went from the hands of one Christian organization to another. In 1965, the Harold Martin Evangelistic Association from Quebec, Canada, purchased Dark Island from the Christian Brothers for $35,000. The president of the association, Dr. Harold George Martin, previously served as chaplain in the Royal Canadian Air Force and was then director of the Christian Homes for Children in Quebec.

After taking possession of the castle on Dark Island, Harold Martin had its name changed to Jorstadt Castle. Martin's family name had originally been Martin-Jorstadt. His Norwegian grandfather dropped the name Jorstadt from his surname when he moved to England. Martin and his wife, Eloise Dorsey Martin, used their island castle for a private retreat for ministers and missionaries.

For the first time in its history, the castle's doors were swung open to the public for a weekly Sunday morning chapel service. Dr. Harold Martin led most of the services himself, often accompanied by his wife, who was a trained vocalist. In 1966, the first year the Martins held chapel services, Dr. Martin announced that his associate and well-known British evangelist Leonard Ravenhill would be helping with some of the services.

The chapel (formerly the breakfast room) was often full to capacity on Sunday mornings. Although the room was set up to comfortably seat 90 people, on many occasions—especially when the weather was nice and the water calm—a surplus of the congregation overflowed onto the large balcony. (Courtesy of the Thousand Islands Sun.)

Jorstadt Castle

Chippewa Bay
New York

In 1978, Harold Martin commissioned a young artist to do a drawing of Jorstadt Castle. Today, John Morrow has become one of the most renowned artists in the North Country, and his original Jorstadt drawing is still available for purchase both in black-and-white and in watercolor. (Courtesy of John Morrow.)

Another of the North Country's best-known artists, Michael Ringer, featured the castle in one of his river paintings, *Skylight over Dark Island Castle*. This and many of his other works are now featured in his art galleries in Clayton and Alexandria Bay. (Courtesy of Michael Ringer.)

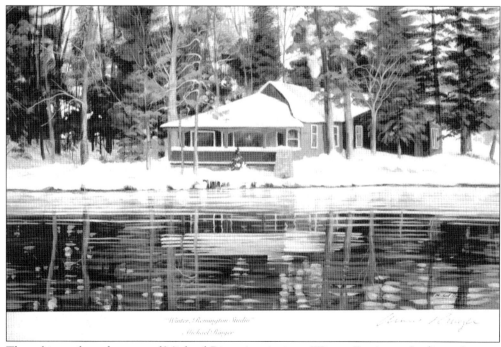

The subject of another one of Michael Ringer's paintings, *Winter, Remington Studio*, is the very cottage at Ingleneuk where, almost 100 years earlier, Frederic Remington sat and painted the castle on Dark Island.

North Country photographer Ian Coristine has also featured Singer Castle in several of his best-selling works. This dramatic photograph, taken from behind a passing freighter, is found in his book *The Thousand Islands*. (Courtesy of Ian Coristine.)

Typical of many of Ian Coristine's photographs taken from his own airplane, this aerial view of Singer Castle and a passing seaway freighter is similar to one that can be seen in his 2005 release, *Water, Wind and Sky*. (Courtesy of Ian Coristine.)

Throughout the period that the castle was owned by the Martins, the drawing room featured color portraits of Harold and Eloise Martin at opposite ends of the room. When asked what most motivated him in life, Harold Martin responded, "To know God and to make Him Known."

"I wish that everything I wrote could be a statement of faith in the godliness of God, and the manliness of man. Directing my words to Everyman: to both the thoughtful, and the unthinking. Making it clear that, on God's part, the gift of life is complete, inherently containing the potentials of purpose and beauty. And, for man's part, life's purpose and beauty may be found by those who take the trouble to seek."—Eloise Dorsey Martin.

One Sunday in the early 1980s, Harold Martin asked if anyone in the congregation happened to play the piano. From that time on, one of the guests, Patty Wilson, became a regular pianist and soloist at the Jorstadt Castle services. She also became a close friend of the Martins.

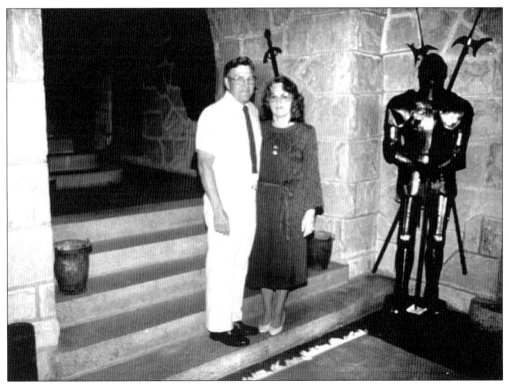

In 1985, when the Martins were no longer able to be there regularly, Jorstadt Castle appeared on the market at an initial asking price of $5 million. Harold Martin asked Harvey and Flo Jones to help him keep the Sunday morning worship services going in his absence. The Joneses graciously began to run the services (on an entirely volunteer basis). Harvey Jones has since become an ordained pastor and has officiated at several weddings at the castle.

Patty Wilson continued to play the piano and sing at the chapel services alongside Harvey and Flo Jones. When Patty married Robert Mondore in 1989, he began to attend services as well. The Mondores eventually made one of the first Web pages in tribute to Jorstadt Castle (www. gold-mountain.com/pm.html).

When it became evident that the castle was to be sold, Robert Mondore began filming services, taking pictures, and recording as much of the castle's rich history as he could find. He eventually filmed and produced the castle's first full-length documentary video, released in 2002.

Harold and Eloise Martin still came and visited their beloved castle even after the Joneses began leading the services. Eventually, Eloise's health no longer allowed her to make the difficult trip. Harold Martin died in November 1999. The Martins will always be remembered by those who had the privilege of attending chapel services at Jorstadt Castle.

After Harold Martin's death, the ministry was owned and operated by his son Wycliffe Martin, who was named president of the Harold Martin Evangelistic Association. Wycliffe Martin allowed the Joneses to continue the services in the Martins' absence. The Joneses lived in the castle during the summer months, so the services went on, regardless of the weather. On particularly windy days, this meant a congregation of two.

ousand Islands Sun

Combined with "On the St. Lawrence"
— PUBLISHED EVERY WEEK SINCE 1901 —
Everything In The Thousand Islands Revolves Around "The Sun"

.O. BOX 277, ALEXANDRIA BAY, NEW YORK 13607 - WEDNESDAY, AUGUST 19, 1999 — Single Copy Price - 60 CENTS

Candy and Dan Cookes

THE SECRET — Movie Caper
by Laurie Lind Petersen

Chippewa Bay -- Now it's okay to tell the world that a major motion picture was partly filmed at Jorstadt Castle a couple of weeks ago.

Unless you are in the immediate circle of one of the extras, all of whom were local, you probably didn't hear about it at the time.

That's because the production company, Cranium Films, Inc.-- under the auspices of Universal Studios--didn't want a lot of hoopla. Hoopla is for when the film comes out. The Dark Island work was just about getting the thing in the can.

Local site rep Dan Cookes ("whatever that means," he laughs) was responsible for hiring extras and lining up boats with drivers for the film, *The Skulls*.

Based on a scull racer belonging to Yale University's Skull and Crossbones Society, according to Dan, *The Skulls* stars--for one-- Craig T. Nelson, and, for another, *Dawson's Creek's* Josh Jackson.

The other two main actors are Paul Walker and William Peterson.

Dan says the principal actors weren't here, but a double was used for a take that was supposed to feature Jackson.

Nobody here is really sure what the plot line of the movie is. "I think they were just being protective of their material," says one of the extras, Frank Bergevin of Alexandria Bay.

He played a Yale alumnus along with eight other local men; seven 18- to 21-year-olds played Yale freshmen.

"Our only direction," he re-members, "for us guys that were,

the crew came by car. All stayed in Gananoque.

Meanwhile, Dan had been con-scripting local boaters and buddies for their fifteen minutes of fame. Or, in this case, ten seconds.

That's about how much of the day-long filming session probably will survive in the movie.

"As long as we don't end up on the cutting-room floor," adds alumni actor Harvey Jones (in civil-ian life, minister at Jorstadt).

"But I don't see how we could, because these were the final scenes."

Coincidentally, Alexandria Bay resident John Freeman worked on both *The Skulls*, and subsequently, a Seattle raceboating film.

An incomplete (and un-spell-checkable) list of other local one-day actors includes Jason Albright,

In 1999, Jorstadt was contacted by Cranium Films (a division of Universal Studios) about filming some scenes there for a movie. In 2000, *The Skulls*, starring Joshua Jackson, Paul Walker, and Craig Nelson, hit theaters all over the world. Because the story was to have taken place in the 1950s, a local antique boat society was invited to participate, along with several locals and vintage boat owners. Dan Cookes was one of the local people employed by the production company. (Courtesy of the Thousand Islands Sun.)

Directed by Rob Cohen, *The Skulls* is a suspense drama based on Yale University's oldest secret society, Skull and Bones. Rather than filming on Deer Island (pictured), where the actual society is said to have met, the movie featured several shots of Jorstadt Castle.

Arriving at the Jorstadt boathouse

. . . The secret movie caper

(Continued from page 1)

from Utica."

Filming wasn't only a matter of jouncing around in the boat looking Ivy League-ish.

"We had to stop filming several times because of ships and waves," Dan remembers.

Harvey Jones remembers, too.

"We line all the boats up," he recounts, "six big wooden boats in a formation, and get up to speed.

"We turn away from the island, and the guy on the loudspeaker says, 'Guys, this is fantastic, this is a take.'

"So we were bobbing around in the water while they were looking at the film, and they said, 'Guess what--you have to do it again.'

"We had to do it seven more

Two scenes were filmed from this Rockport tourboat.

Dan Cookes gave the crew tours of the area and helped them locate various sites, including a boathouse resembling one at Yale. Cookes also lined up rescue divers, two support boats, and the six wooden boats and drivers featured in the movie. In the lineup, his own wooden boat (pictured) was included. Originally, the members of production company planned to film from the castle grounds but changed their minds because of immigration laws (the film crew was made up mostly of Canadians). Instead, they rented a little tour boat from Rockport at the cost of $500 an hour and filmed everything from the boat. (Courtesy of the Thousand Islands Sun.)

The filming went on for an entire day and through countless retakes by the antique boaters. In the end, the castle made three appearances in the movie as the hero was transported to and from the secret society's posh meetings. The vintage boat owners were dressed in costumes appropriate to the time period—but perhaps a bit uncomfortable in the 90-degree weather on the day of the filming. The drivers can be seen traveling in a V formation, with Dan Cookes's *Chanticleer* leading the pack. (Courtesy of Universal Studios Licensing LLLP.)

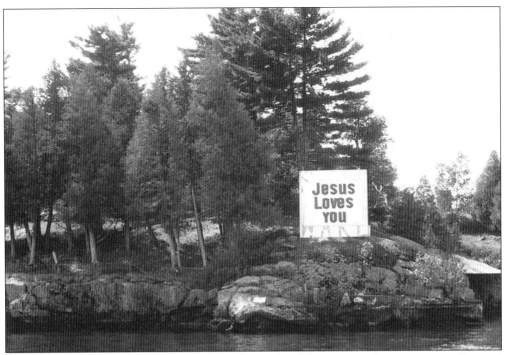

For nearly a decade, the castle remained on the market. There were, of course, many offers and even more rumors about the castle being sold. Some rumors claimed that Michael Jackson and Steve Forbes were looking at it. Throughout it all, the Sunday services went on and boaters continued to attend and participate. One even transformed the "No Wake" sign to something many felt was much more appropriate.

In July 2002, a group of investors called Dark Island Tours purchased the island and its castle for $1.8 million. The sign came down and was soon replaced by a new one. The owners planned to restore the castle and related structures to their original state. After these massive renovations, they planned to open the castle doors to the public once again.

At great expense to the castle's new owners, the repairs got under way. Gradually, the castle was restored to its pristine condition. On August 2, 2003, the doors of the newly renamed Singer Castle were opened to the public. And again, the people came. In their first short 10-week season alone, over 6,000 visitors came to tour the now 100-year-old castle.

By the summer of 2004, several area tour boats had begun to feature trips to the newly remodeled Singer Castle in their advertisements, drawing even more people to the castle. Hundreds of curious tourists came to see the castle and walk through its exquisitely restored rooms and halls.

Frederick G. Bourne, fourth president of the Singer Sewing Machine Company, had a magnificent castle designed and built on his own private island in 1905. The castle was funded from the profits generated by one of the most successful manufacturing companies in the world and by the man who helped make his business so successful.

Some 100 years later, Singer Castle stands as a monument to a successful business that still manufactures sewing machines all over the world. It also stands as a memorial to the man who had it built, living his life, in business and pleasure, family and faith, to the fullest.

Harold and Eloise Martin always ended the Sunday chapel services at the castle with the same song, "God Be with You Till We Meet Again."

"The rarities of this beautiful castle should be seen by people of our time. The beauty and wonders of [Singer] Castle must literally be seen to be believed; for such enchanting places are seldom built more often than 'once upon a time.' "—Eloise Dorsey Martin.